MW00915818

THANK YOU

Katie Michel

Maggie, Elsie, Theo, Laura, and Kathy

Grant and Mary Webster

Sadie Pop and Claire Boo

Brad Ewing, Leslie Miller, and Hollis Witherspoon

David Steinberger and Jennifer Joseph

Amy and Sophie

This book is based on *Forty-Three Monsters*, a limited edition artist book by
Arthur Bradford and Chuck Webster, published by Planthouse, Inc. (2014).

Designed by Scott Idleman / BLINK
43 Monsters © 2015 Planthouse, Inc. Text © Arthur Bradford, Drawings © Chuck Webster.
All rights reserved. ISBN 978-1-933149-92-9. Printed in South Korea.
Library of Congress Cataloging-in-Publication data is available.
For information, please address Manic D Press, PO Box 410804, San Francisco CA 94141
www.manicdpress.com

43 MONSTERS

STORY BY ARTHUR BRADFORD DRAWINGS BY CHUCK WEBSTER

MANIC D PRESS
SAN FRANCISCO

PLANTHOUSE
NEW YORK

Greetings, friend! I am **Brokeosurus**, chosen by the others to write down a few things. I'm the historian of the monsters and the first thing you should know is that we were created by Charlie Wedster, a clever and somewhat strange boy. All hail Sir Charlie!

How am I writing this? I have no fingers with which to hold a pen! But I have long fangs and have learned to make words by dipping them in ink. See how clever I am?

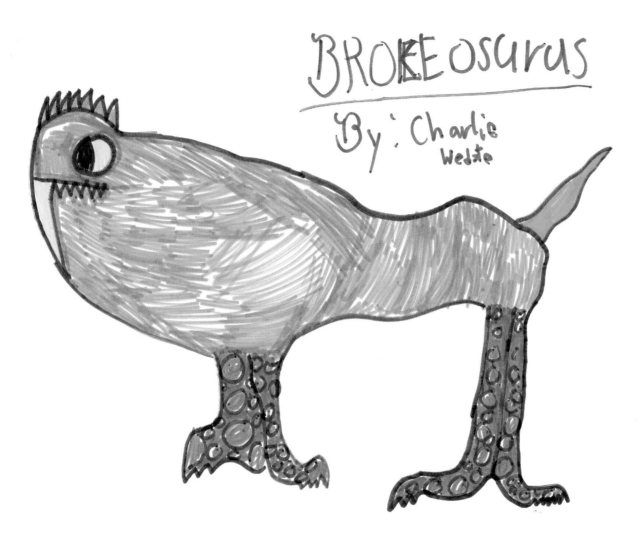

BROKEOSURUS

By: Charlie Wedte

We monsters are all smart but **Soreranvon** here is the smartest. You can tell by his eyes. They say he looks a bit like Charlie Wedster, except for the winged hands and red teeth.

Soreranvon is my best friend, and we can talk for hours. We share our dreams and fears. Most of all, we fear the darkness of the drawers, where sometimes Charlie shuts us for days on end. What if he leaves us there and does not return?

"We will no longer be able to frolic and fight," said Soreranvon. "It will be dark times, my friend."

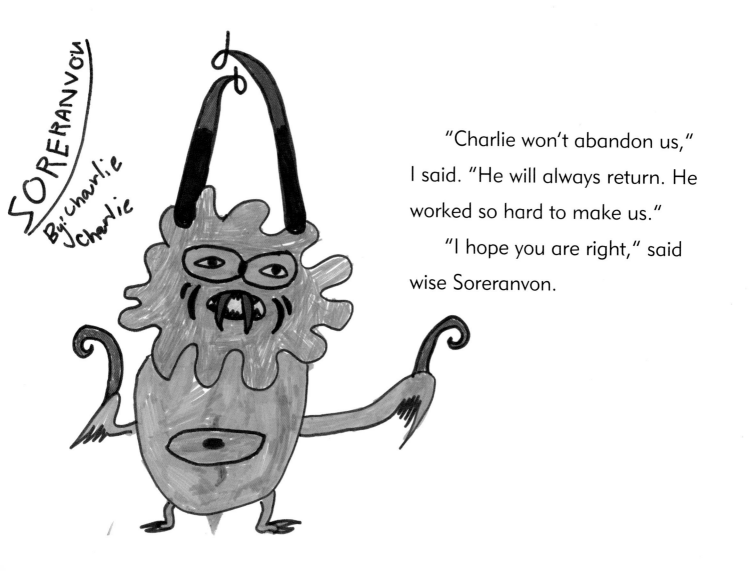

SORERANVON
By: charlie Charlie

"Charlie won't abandon us,"
I said. "He will always return. He
worked so hard to make us."

"I hope you are right," said
wise Soreranvon.

Fanzous here was jealous of some other monsters, in particular Spikey and Zinggo, who could dart around on many legs and not lose their balance as Fanzous often did.

"But you have such a nice long tail and sturdy horns," I pointed out.

"That means nothing to me," said Fanzous. "I want to be loved. Oh, who will love a creature like me?"

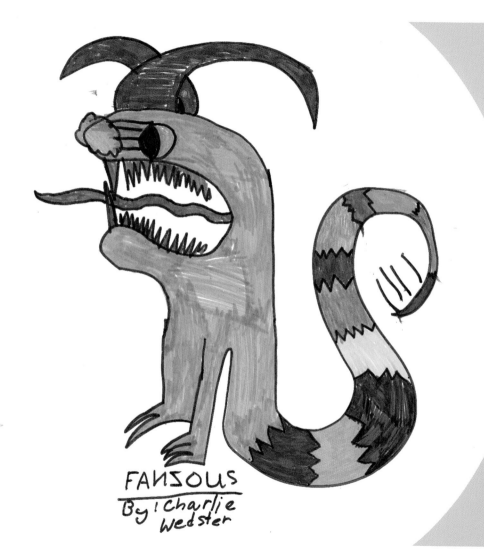

FANZOUS
By: Charlie Wedster

Then Charlie Wedster introduced Fanzous to Bluey, a creature with no legs or arms at all. Unlike Fanzous, Bluey does not mind the way she was made.

Fanzous took to following **Bluey** around like a puppy, offering to help her with anything she might need done. She was grateful for his assistance and now that Fanzous felt useful he complained less about the way he looked.

We all love Bluey. She is just so blue and simple.

BLUEY.

By: Charlie Wedster

Whenever something is broken or there appears some unexplained mess, we know who is behind it.

Zinggo, of course. His favorite thing is to knock over Charlie's buildings, the ones he makes with plastic snap-together blocks when he is not busy creating us. If Charlie turns his back for just a moment, WHAM! Zinggo darts right in.

Look at him. Would you trust a fellow like that?

One time we convinced Alyosurus to sneak into Charlie Wedster's kitchen. He is brave, even if he possesses more muscles than brains. He snuck into the kitchen and rooted around the highest shelves and found where Charlie's father hid the holiday candy.

What a candy party we had! We ate it all and left wrappers on the floor.

"Perhaps we should have saved some candy for later," said Soreranvon. We agreed with his wise thoughts. Our bellies hurt for hours and Charlie scolded us for the mess we had made.

"You didn't even share any with me," he said.

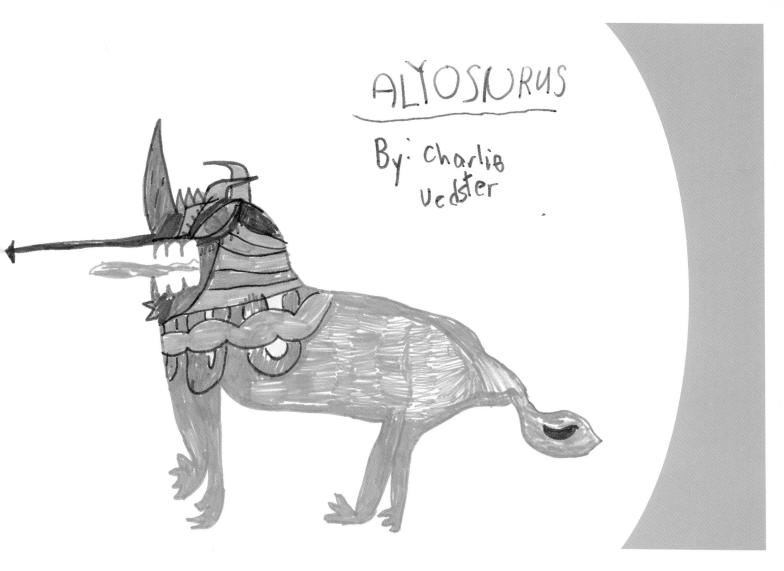

ALYOSURUS

By: Charlie Vedster

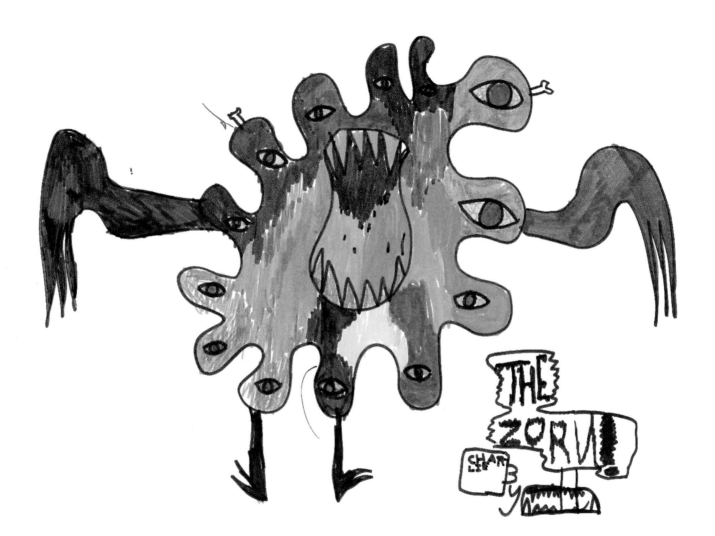

Charlie Wedster once took **The Zorn** with him to school. The Zorn said everyone there loved him but Charlie Wedster wasn't so sure.

"Why do you spend all your time making monsters?" the other children asked.

"You fools!" cried The Zorn. "He is our creator! You should treat him like a king!"

After that, Charlie didn't bring creatures like The Zorn to school.

There came a day when Side Fighter and The Zorn decided to have a fight. It was The Zorn's fault, if you ask me. He was very proud of himself, with all of his eyes and multi-colors. He felt Charlie had worked harder on creating him than the others, which hurt all of our feelings. So little Side Fighter decided to show The Zorn that it wasn't the time spent on something that is the true measure of its greatness. It's the spirit!

Side Fighter was quick, clipping like a crab and frustrating The Zorn. Who cares about lots of eyes and majestic wings? The Zorn began to yowl and moan. When Side Fighter snipped his skinny black leg, the mighty Zorn cried out, "I am sorry for underestimating you, Side Fighter!"

SIDE FIGHTERS

By: Charlie Webster W

"I'm more concerned about your snooty attitude," said Side Fighter.

"I'll work on that," said The Zorn. And from then on, he did his best to be a more humble monster.

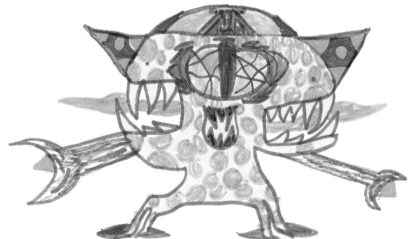

One day Charlie Wedster carefully picked out some monsters and showed them to Alexandra, a girl who lived nearby. She said, "What are these, Charlie?"

He tried to explain but he took a long time and mumbled about our special powers. Soon Alexandra seemed distracted by other things. Spikey here was upset. Spikey loves Charlie and she called out, "Hey! Hey, you! I can breathe fire! Look at the spikes on my back and tail!"

Alexandra ignored Spikey and wandered around Charlie's room. "So you like to draw?" she said.

"Draw?!" cried Spikey. "He gave us life! We love him! And so should you!"

Charlie told Spikey to keep it down, and Alexandra said, "Who are you talking to?"

"No one," said Charlie.

Afterwards, Charlie said to Spikey, "Stay out of my business next time."

"Don't you love us anymore?" asked Spikey.

"Sure, I do," said Charlie. "I guess..."

SPIKEY

By charlie Wedster

Hot Stuff! can always be counted on to start a party. Look at that flame! We like Hot Stuff! but some of us are afraid he's going to burn the whole place down. He can be careless with his hot breath. One time he tried to toast a bagel for Charlie Wedster. A small fire started underneath the kitchen table and Charlie got in much trouble.

HOT STUFF!

By: Charlie Webster

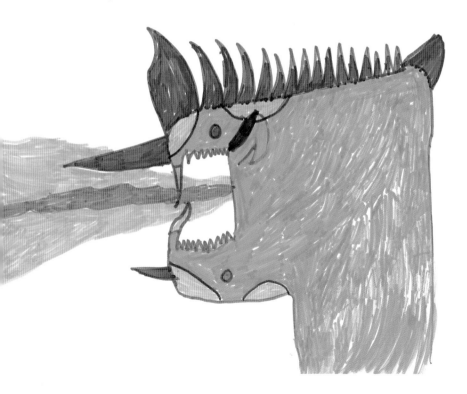

When Uglyosorus first arrived on the scene, everyone said, "Don't tell him what his name means!"

"Oh, he'll figure it out," said The Zorn.

But he didn't. Poor Uglyosorus walked about introducing himself and wondering why everyone smiled when he said his name. Finally, Spottyosorus told him the truth.

"You're ugly, my friend," he said.

"Well," said Uglyosorus, straightening himself up as best he could. "I'm just as Charlie made me. At least I'm not covered in ridiculous spots."

"I'm covered in spots?" said Spottyosorus. "What? Why didn't anybody tell me?"

Spottyosorus was upset for some time, but the same could not be said for Uglyosorus, who soon made friends and became so busy that he forgot about the way he looked.

UGLY OSORUS

By: Charlie Wedster

SPOTTYOSORUS

By: Charlie
 Webster

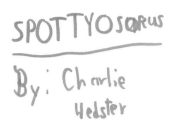

Spotty had never seen himself before. This changed on the day a few of us ventured into the bathroom to observe the operation of the toilet. Spotty gazed at his reflection in the mirror.

"Now, wait a minute," said **Spottyosorus**. "Do you mean to tell me that I am covered from head to toe in spots?"

"It's true," we all said.

"I want a different look," Spottyosorus said, "something more fierce. We are monsters, aren't we?"

Uglyosorus offered to switch bodies with Spotty, but Spotty didn't take him up on it.

"Is anyone else concerned that we aren't doing the things monsters are supposed to do?" asked Spotty. "Shouldn't we be out scaring people? When was the last time we did that?"

This was a good point and gave us all something to think about. Alyosorus said he would be happy to scare the next person he saw, but for now he wanted to watch the toilet flush again. He tipped the little silver handle, and we all gazed down at the swirling water.

I will be honest with you about **Aringoe**. He is as clumsy as can be. Even he knows it's true.

"Yes, I know it," he says. "I trip over my feet. I can't hold anything without dropping it. Why, oh why, did Charlie make me this way?"

But we love you, Aringoe. And you can breathe fire, which most of us cannot do.

ARINGOE

BY: CHARLIE wesster

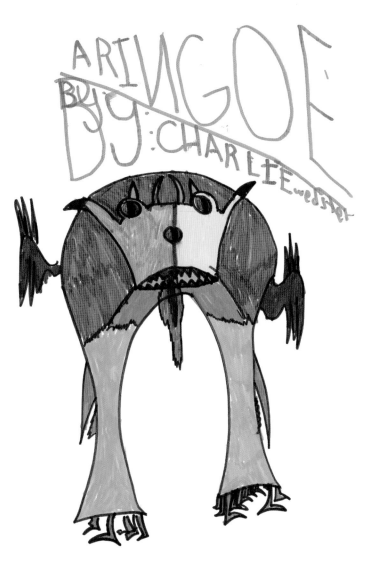

The thing you should know about **The Magic Eye!** is that she isn't actually able to see much. She is nearly blind. She runs right into things and is very anxious, like Charlie's dog, as a matter of fact. But her eye is magic. If you look into it, wish for something and say the right words, you will get your wish. It can still happen, just look into The Magic Eye!

THE MAGIC
EYE!
By: Charlie Wedster

ALEEOOMM
Dog CHARS

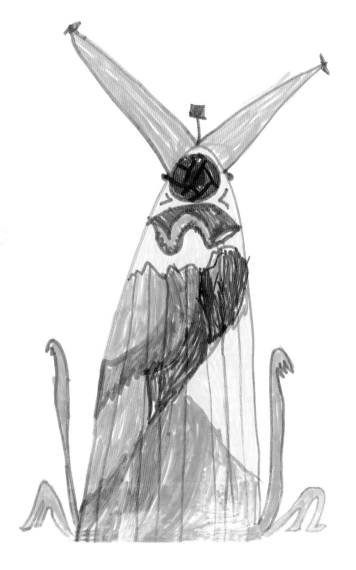

Oh, Aleeoom, you always gave us wise advice, like the time you said don't swim in the porcelain water bowl we came to know as the toilet.

I had always liked **Worz**. He was smaller than the others and very polite.

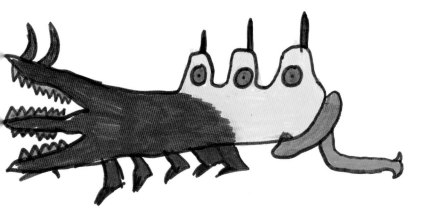

WORS
by: Charlie.

But then it became known that he had eaten several of our monster friends, which explained some of the disappearances. Watch out for him!

Sometime we monsters get mad and lose our tempers.

Sorp-a-Rokose here will fly into a rage and cannot be calmed.

One time, Soreranvon had to smother our friend Sorp in mayonnaise.

This was the only way to calm him down.

Mayonnaise calms us monsters. Ice cream, too, when we can find it.

Spottyosorus once remarked that Sorp-a-Rokose had the proper

temperament of a monster and we should all try to be more like him.

"That's a terrible idea," said Soreranvon. "Why would we want to

be cranky like him?"

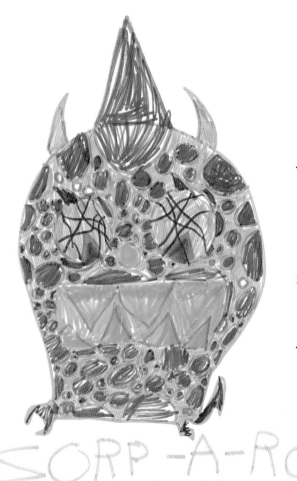

"We need to act scarier," said Spotty. "That's the purpose of monsters."

"I disagree," said Soreranvon.

"Ahhhh!" screamed Sorp-a-Rokose. "Let's scare someone and make them cry!"

We gave him a little mayonnaise then, and turned the conversation to something more pleasant and constructive.

SORP-A-ROKOSE!
BY: CHARLIE
WEDSTER

LIZERD

OF OS

By: charlie webster

It might be hard to tell from this picture, but **Lizerd of Os** is enormous. He dwarfs most of us, and thunders through the hallways with heavy steps. Make way for the Lizerd of Os!

Lizerd sometimes wakes up Charlie's parents, and has caused many problems with his habit of sneaking food from the refrigerator. All of the pets in the neighborhood are afraid of him, and the dogs bark loudly when he marches by their homes.

This fellow was sort of grouchy and we all gave him space.

The horns! The teeth! The horns!

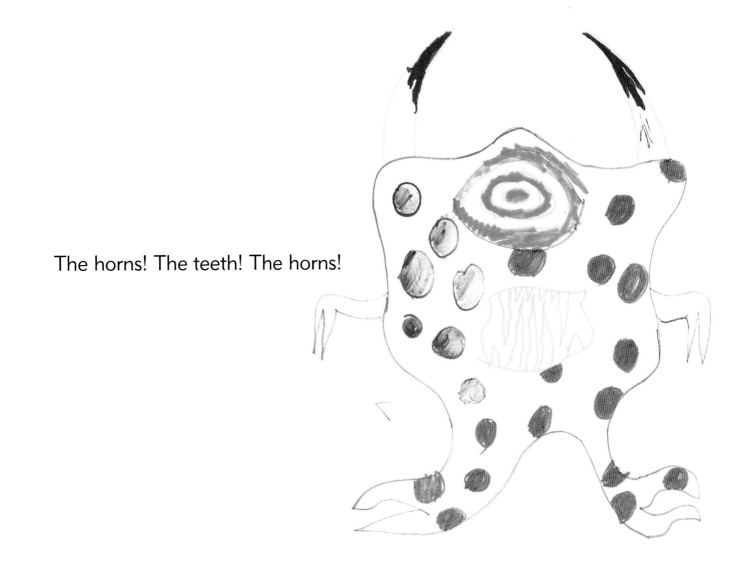

We never knew this fellow's name but we were all afraid of what he might do if he got mad.

Enswozu is a good friend. Unlike most of us, he can dance quite well. Enswozu knew that he was a good dancer, and talked about entering a dance contest called *Dance Fever*. We all encouraged Enswozu to pursue his dancing dreams and fly to Hollywood where the dance contest took place. But in the end he decided to stay home. He claimed he would miss us all too much.

"Who wants to be famous anyway? Not me," he told us. But we didn't believe him about that.

Spickosorus distinguished himself by catching a pigeon once.
Or perhaps it was a hen. We didn't know what to do with it though and
it flew away before we could make up our minds.

By:Charlie

SPICKOSORUS

"It's not my fault I was made this way," cried **Peterdon**. "You should talk to Charlie."

"I'm sorry for poking you at night and bothering you in the dark. It's just who I am. I wanted to be a scientist of some sort, maybe a college professor."

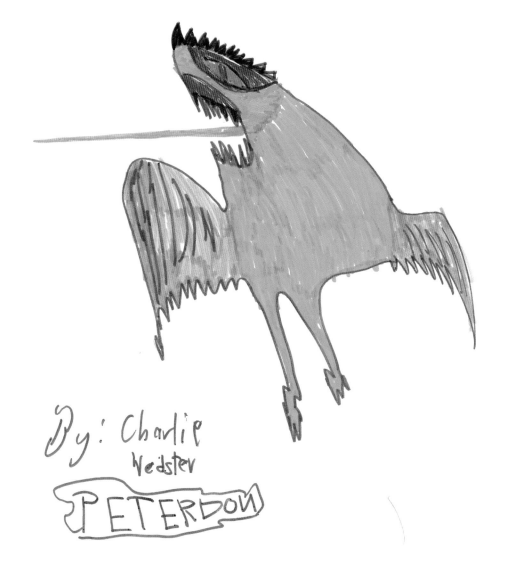

By: Charlie
Webster

PETERDON

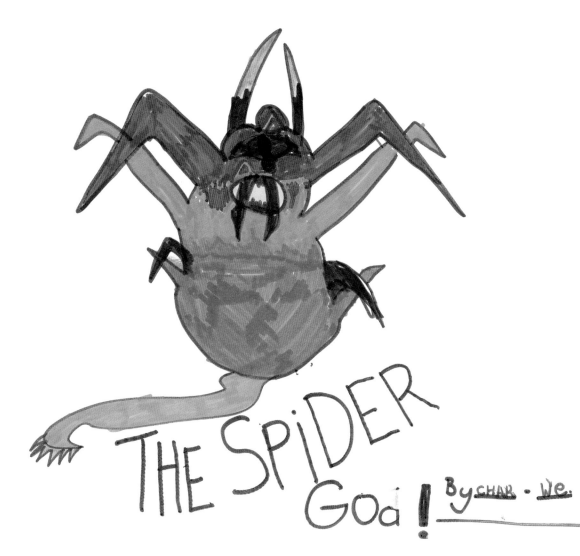

THE SPiDER
Goa ! By CHAR - We.

The Spider God is another troublemaker. One time, Peterdon was feeling blue and in one of his moods. The Spider God said to him, "Hey, let's go pester some of those birds outside."

So they snuck out and scared a bunch of birds. It gave them great joy to hear the birds squawk and fly into the air with fright. But later Peterdon felt terrible about this and tried to apologize, which didn't work at all. You can't say "Sorry" to a bird if you're a monster.

If you ever look outside and see birds fly away for no reason, I bet the one who made them go is The Spider God.

Pink-Posoruso was full of mischief, too. She caused Charlie Wedster's mom to slip and fall down the stairs, twisting her ankle. It all could have ended for us right there.

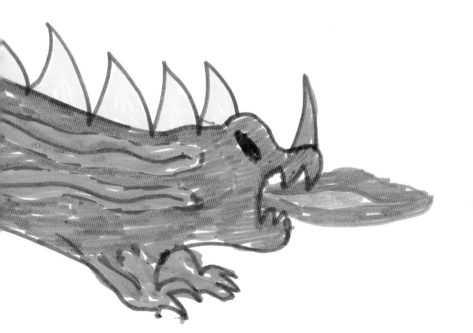

PINK-POSORUSO

By: Charlie
Wedster

HAVINKOSORUS

By: Charlie Wldoter

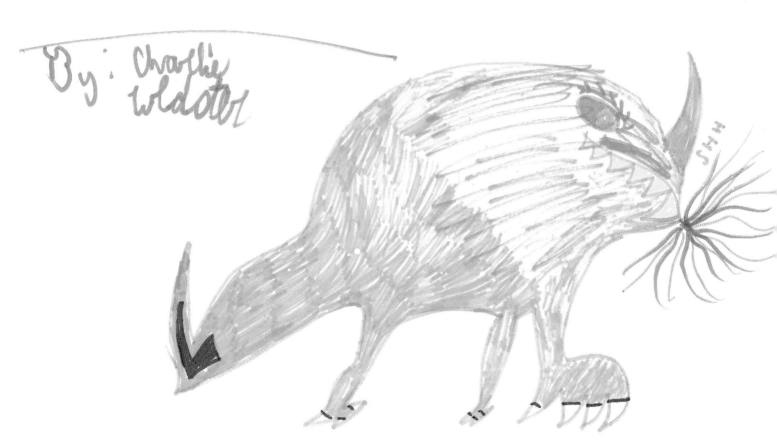

Havinkosorus wanted to be a dancer like Enswozu. She practiced and offered to be Enswozu's partner on *Dance Fever*. They would have made a dashing couple, but Havi had no rhythm at all. This, along with her three mismatched feet, made things difficult.

You really must beware of the **Heny Devil**. He is one of Charlie Wedster's most powerful creations. Heny likes to eat things that get left behind, like crumbs and half sandwiches. Sometimes Charlie will leave for just a few moments and when he returns, Heny will have eaten his food.

After this happened a few times Charlie became annoyed but he was also secretly pleased because this showed that we were real.

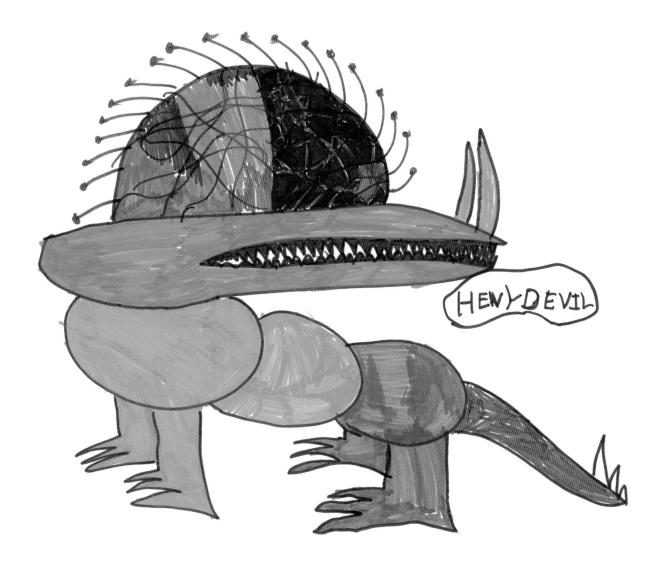

Enswozu's dream of being on *Dance Fever* was almost gone and forgotten. That's when Grayosorus came to the rescue. What grace and flair! Gray and Enswozu began practicing together late into the night, prancing around the basement and wiggling about. One time they knocked over a lamp and Charlie Wedster got blamed. Another time they spilled his milk on the carpet.

When Charlie saw them dancing, he said, "That's amazing." But then he became puzzled and a bit annoyed.

"You're monsters," he told them. "You need to be scaring people and protecting me. What's going on with all this dancing?"

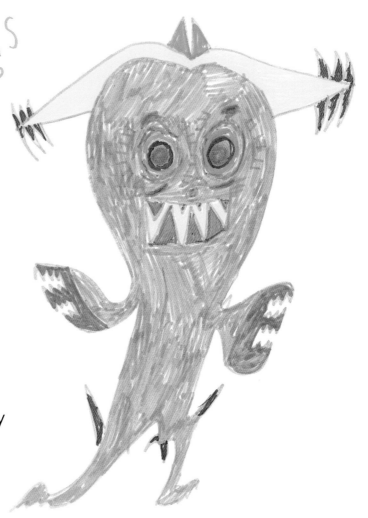

GRAYOSORUS

By: Charlie Wedster

"We are practicing for *Dance Fever,*" explained Grayosorus. "We shall win it all!"

"I'll be surprised if that actually happens," said Charlie Wedster.

It was shortly after the dancing incident that Charlie created **Bankosorus**.

"I need some muscle around here," he said. "Someone who will have my back in a fight."

"But you never fight," said Bankosorus.

"But I might," said Charlie.

BANKOSORUS

By: Charlie webster

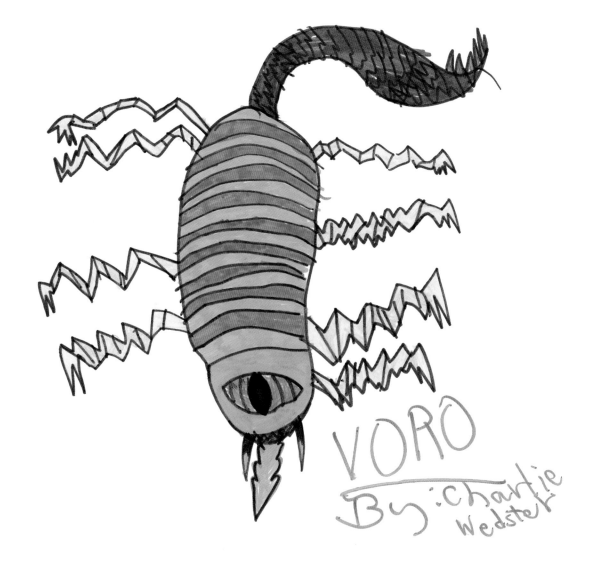

VORO
By:Charlie
Webster

Voro ran away for weeks and no one knew where she had gone. Charlie supposed he'd lost her at a picnic.

It turned out that Voro had caught a ride with a gentleman going south to Florida and had spent some time down there in the sun.

"How was it?" we all asked her, upon her return.

"That man was no fun," she said bitterly. "He watched TV all day and never took me anywhere. The fruit in Florida was delicious though, and I'm not sorry I went."

SIKLOPOSORUS

By: charlie webster

We monsters are insecure. This means we are not sure about things. Ask my friend Sikloposorus and he will tell you all about it.

"I'm always worried about my appearance," he will say. "Will they like my spines? Are my horns scary enough?"

I will tell you the truth: we monsters must growl and spit fire because we are scared of YOU and what you might think of us. Be kind to us monsters, please.

Something happened to Aleofosas. He was always chewing on things, and one time he chewed up a handful of Charlie's plastic snap-together blocks. They didn't agree with his stomach at all.

"I'd be alright," he said, "if only I could have a nice cup of sassafras tea. Do you know where I might find something like that?"

"I'm afraid not," I told him, as he wandered off holding his aching belly.

ALEOFASAS

By: Charlie wedder

Whenever we have parties or stay up late after Charlie Wedster goes to bed, we see **Infocop-acus** scratching little notes with his paws. If things get too rowdy, like the time Bankosurus wrestled with Hot Stuff! and splashed toilet water everywhere, Infocop-acus will come barking in, telling us all to settle down. We don't invite him to our parties anymore.

INFOCOP-ocus

By: charlie

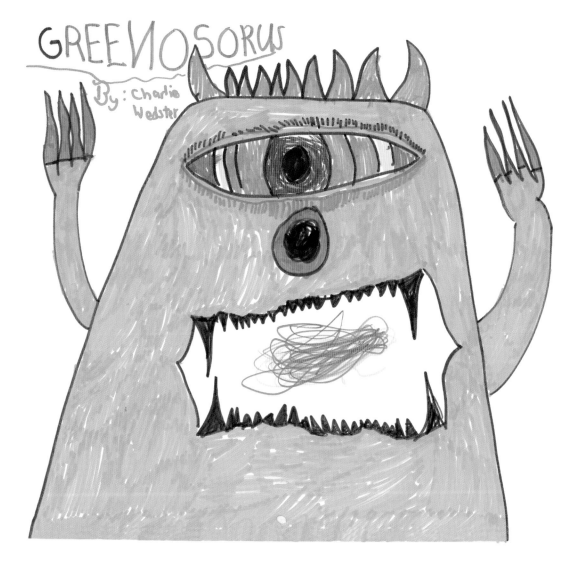

Some say there is great power in Greenosorus's fiery breath.

I say there is only great odor.

CIAWOSORUS

By: Charlie

Clawosorus once challenged Side Fighter to a duel.

"Let's rumble!" he announced. And we all gathered around to watch the two little fellows do battle.

They pranced about for some time, sizing each other up. Clawosorus took a few snaps with his threatening claws. Side Fighter skittered in sideways, his favorite move.

"You won't pull that one on me!" proclaimed Clawosorus.

Then Charlie Wedster walked in and broke the whole thing up. "You can't be fighting like this all the time," he scolded.

"But this is how you made us," protested Clawosorus. "We were born to fight!"

"That's not true," said Charlie Wedster. "I made you to protect me and keep me company."

"Oh," said Clawosorous, looking down at his claws. "I thought these were for fighting."

"Well, they're not," said Charlie.

Imagine our surprise as we all gathered around the television one night to watch *Dance Fever* and who should appear as a special guest but our friend, Kinoporus!

Enswozu was the most shocked. "That was my dream," he said. "He stole it."

This may have been true, but we all had to admit that Kinoporus stole the whole show as well. He was amazing. Few who saw him dance will ever forget it.

Enswozu sulked in the corner throughout the program.

"That little thief doesn't even have same-sized arms," he mumbled as the crowd on TV went wild.

KINOBORUS

By: Charlie Wedster

Wait, who is this guy? I thought I knew every one of Charlie Wedster's monsters. This fellow is new to me. He must have been hiding out somewhere. What are those on his back, quills?

name
GREN A RAM SOUR
By: Marlie

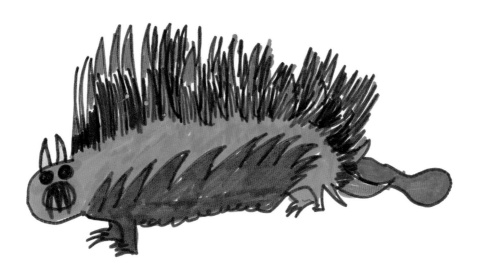

Armadiosorus is playful like a young monkey. We tried to take him on one of our journeys to the outside, just a short trip to the market at night, but he went crazy at the sight of all that food. He ripped into bags of potato chips and cheese puffs, and caused a dangerous ruckus. From now on, whenever we venture out, we leave Armadiosorus behind. He always whines about this upon our return.

Soreranvon makes sure to bring him a small salty gift each time we come home and this tends to calm him down.

ARMADIOSORUS

By : Charlie wœster

KAOSORUS

charlie verstchle

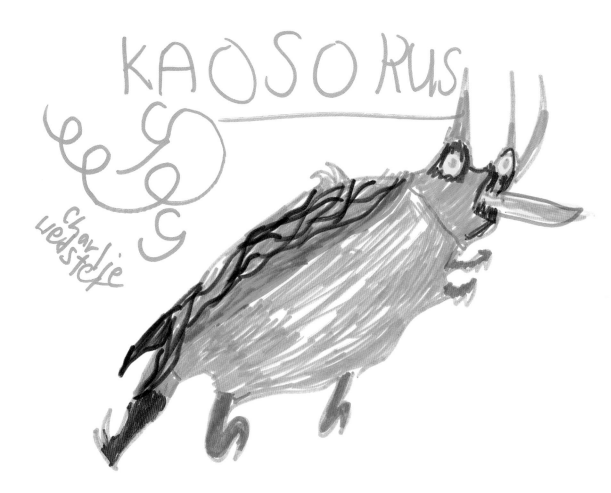

Kaosorus is shy and unassuming. She once had an embarrassing accident with the ceiling fan. She wasn't hurt though and even laughed about it a bit afterwards. We all admired her then, for the ability to laugh at your own misfortune is a true sign of strength.

Ah, The Aloevo. Sometimes we'd see her flying through the air at night, and then hear a little crash when she hit a wall or a lamp.

"These wings Charlie gave me are not fit for flying!" she'd complain.

"But you can snatch things in your powerful jaws," Soreranvon pointed out. He was always trying to be helpful, especially when creatures complained about their powers, which you have likely figured out happens pretty often around here.

ALOEVO

THE by:CHARLIE

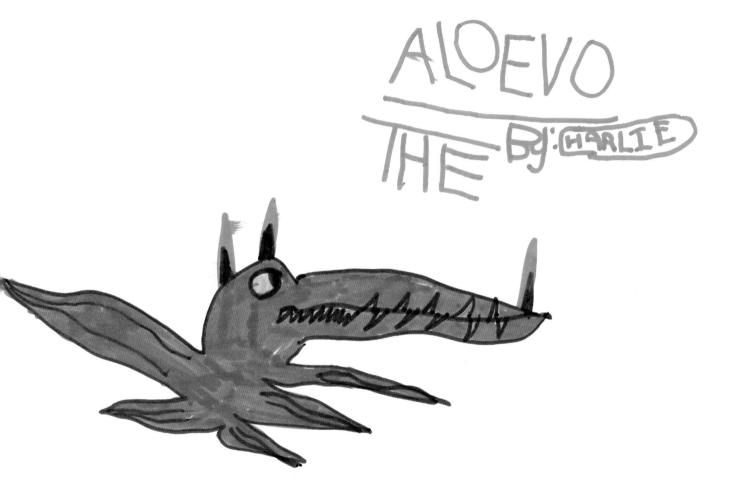

Hankorocka once bit me quite hard when I wasn't looking. I have never been so tempted to use my fangs as I was on that day. Luckily, Hankorocka's mouth is quite small and I have a very tough hide. I took a deep breath and calmed myself down with a scoop of mayonnaise from the refrigerator.

IANKOKOCKA

By: Charlie

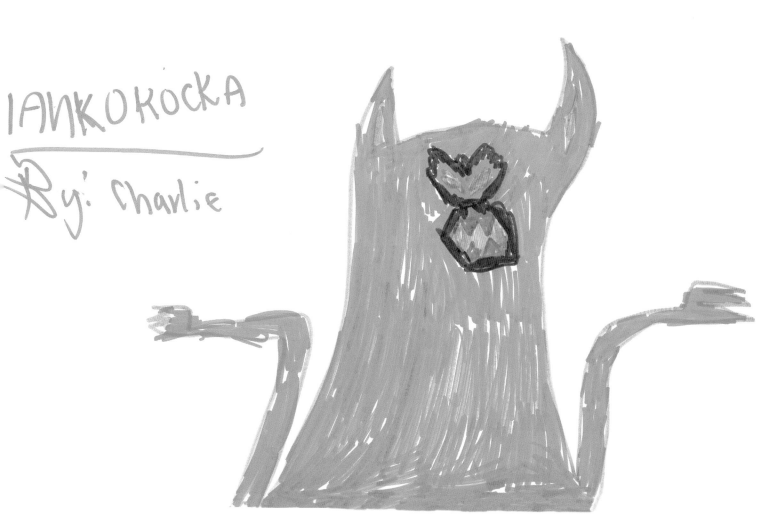

CONGVESOS

Doj: Charlotte webster

Most of us are poor swimmers but Congvesos here is not. He can swim AND breathe fire. Sadly, there are few bodies of water nearby in which Congvesos can frolic.

"Please take me to some water where I might swim!" begged Congvesos.

"I'll think about it," said Charlie Wedster. "It might be fun to see you destroy a boat."

"I will destroy all the boats if you take me there," said Congvesos. Charlie never did take him to a lake or pond so he never got to make good on this boast. We think that was for the best.

Seeosorus is another good friend. Seeosorus had heard he might have relatives on the outside and sought my help in locating them.

"You can write, Brokeosorus," he told me. "Will you write them a letter?"

Seeosorus wanted me to write a letter to a group known as The Dinosaurs, located in The Museum of Natural History in New York City. We composed a friendly note, explaining our situation and asking for a reply.

Many weeks later, a letter arrived from the Museum. Charlie Wedster opened it and read it aloud.

"We appreciate your spirited note to

SEEOSORU:

By: charlie
Wedster

our dinosaurs," the letter read, "but as they became extinct over 65 million years ago, they have no way to respond to your questions. Only their skeletons remain."

"What?" shrieked Seeosorus. "What are they saying? Are there no other creatures like us? Does this mean we are alone?"

"I'll keep working," said Charlie Wedster. "You'll never be alone, Seeosorus, I promise."

"You'd better!" cried Seeosorus, for he was most upset by this news. We all were.

Charlie's mother came in and asked what all the moaning was about.

"We're all alone," cried Seeosorus, "and one day we'll become extinct!" Charlie's mother thought for a minute and said, "Well, maybe Charlie will make you all into a book so that others can remember you always."

"A book?" we said. "What is that?"

"Don't worry about it," said Charlie. "That will never happen."

Then Charlie Wedster sat back down with his magic pens and began to create more monsters.

DRAW YOUR OWN MONSTERS HERE

LOOK U
LOLA -10

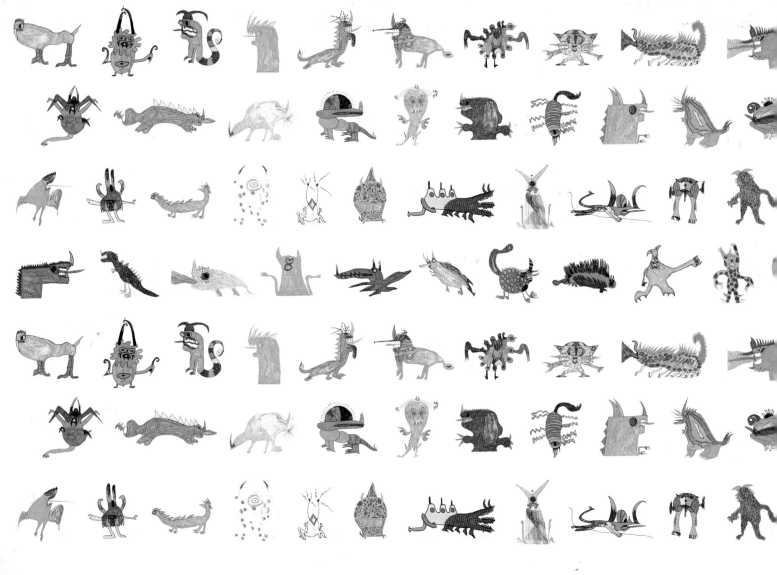